SOUL STORIES

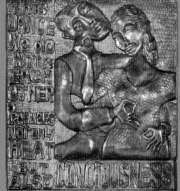

P9-DTR-152

SOUL STORIES
NARRATIVE SCULPTURE BY TERESA MOOREHOUSE

Larson Publications
Burdett, New York

Copyright © 2013 Teresa Moorehouse

All rights reserved. No part of this publication may be reproduced, stored in a retrieval system, or transmitted, in any form or by any means electronic, chemical, optical, photocopying, recording, or otherwise without prior permission in writing from the publisher.

Library of Congress Control Number (LCCN) 2013931577
ISBN-10: 1-936012-62-6
ISBN-13: 978-1-936012-62-6

Publisher's Cataloging-In-Publication Data
(Prepared by The Donohue Group, Inc.) Printed in China

Moorehouse, Teresa.
 Soul stories : narrative sculpture by Teresa Moorehouse.

 p. : col. ill. ; cm.

 ISBN-13: 978-1-936012-62-6
 ISBN-10: 1-936012-62-6

 1. Bronze sculpture, American. 2. Narrative art. 3. Spiritual life--
Poetry. 4. Meditations. I. Title.

NB237.M667 A4 2013
730/.92 2013931577

Cover: **Open Doors,** *see pages 32–33*
Photos: Cascadilla Photography
Design: Paperwork

Published by Larson Publications
4936 NYS Route 414
Burdett, New York 14818 USA
larsonpublications.com

22 21 20 19 18 17 16 15 14 13
10 9 8 7 6 5 4 3 2 1

DEDICATION

I dedicate this book to my beloved daughter Isadora Gabrielle Leidenfrost, who is the best teacher I have ever had. The courage and wisdom I've been forced to find to be an example for her has amazed me.

narrative
sculpture by

Teresa
Moorehouse

THE ART

Works in order of appearance. Dimensions are in inches tall by wide (H x W x D) and deep where applicable.

The Healer, 2003. Cold cast bronze, 4 x 2.5 x 1.
Open edition: $50

In the Spirit of the Apple Tree, 2004. Cold cast bronze
and red acrylic, 10.25 x 8.25, framed. Open edition: $175

The Phoenix Cycle, 2003. Cold cast bronze, 10.25 x 8.25,
framed. Open edition: $175

The Angel, 2005. Cold cast bronze, 10.25 x 8.25, framed.
Open edition: $175

Emergence, 2004. Cold cast bronze, 10.25 x 8.25, framed.
Open edition: $175

A Woman with Her Companions, 2011. Cold cast bronze,
10.25 x 8.25, framed. Open edition: $175

Foliage Spirit, 2005. Cold cast bronze, 10.25 x 8.25,
framed. Closed edition.

Quiet Water, 2003. Cold cast bronze, 10.25 x 8.25, framed.
Open edition: $175

World Tree #2, 2008. Cold cast bronze, 10.25 x 8.25,
framed. Open edition: $175

The World Tree, 2004. Cold cast bronze, 15.5 x 13.5,
framed. Open edition: $600

Initiation, 1980. Cold Cast Bronze, 15.3 x 8.75.
Closed edition.

The Mystic, 2003. Cold Cast Bronze, 15.5 x 13.5, framed.
Open edition: $600

Open Doors, 2006. Cold cast bronze, 15.5 x 13.5, framed.
Closed edition.

Secret Keeper in the Garden of Personas, 1980.
Cold cast bronze, 15.5 x 13.5, framed. Closed edition.

The Kiss, 2006. Cold cast bronze, 15.5 x 13.5, framed.
Closed edition.

This Dance We Do, 2010. Cold cast bronze, 19 x 16,
framed. Open edition: $800

A Woman's Contemplation, 2009. Cold cast bronze,
15.5 x 13.5, framed. Open edition: $550

Greeting the World Head On, 2009. Cold cast bronze,
15.5 x 13.5, framed. Open edition: $550

Elements of the Labyrinth, 2010. Cold cast bronze,
25.75 x 14.75, framed. Open edition: $975

The Golden Fruit, 2010. Cold cast bronze, 37.25 x 11.75,
framed. Closed edition.

The Fallow Time, 2012. Cold cast bronze, 37.25 x 11.75,
framed. Open edition, $975

The Spirit Tree, 2012. Cold cast bronze, 25 x 13, framed.
Open edition: $975

The Alchemical Marriage, 1995. Cold Cast Bronze,
71 x 30. Open edition: $12,000. Commissioned.

Images of Knowledge, 1981. Bronze and Maple, 84 x 36.
Open edition: $20,000. Commissioned.

The Dance of the Body Image, 2003. Cold cast bronze,
13.5 x 15.5, framed. Closed edition.

The Divine Feminine in Her Light and Dark Aspects,
2003, Cold cast bronze, 5.5 x 5.5. Closed edition.

Sound Calling, 2003. Cold cast bronze, 5.5 x 5.5.
Closed edition.

The Million Year Old Woman, 2002. Cold cast bronze,
12-inch disk. Closed edition.

Sleeping Beauties Awakened, 2002. Cold cast bronze,
19 x 16, framed. Closed edition.

Butterfly Woman, 2002. Cold cast bronze, 13.5 x 15.5,
framed. Closed edition.

Changing Our Perception, 2002. Cold cast bronze,
19 x 16, framed. Closed edition.

Direct Connection, 2002. Cold cast bronze, 11.75 x 15.75,
framed. Closed edition.

The Skeleton Woman, 2002. Cold cast bronze, 19 x 16,
framed. Closed edition.

Linked, 2002. Cold cast bronze, 13.5 x 15.5, framed.
Closed edition.

Sisters in Wisdom, 2005. Cold cast bronze, 15-inch disk.
Open edition: $600

Women Waiting at the Garden Gate, 2011. Cold cast
bronze, 17.25 x 17.25, framed. Open edition: $1,500

Symbolic Incorporeal Beings, 2011. Cold cast bronze,
17.25 x 17.25, framed. Open edition: $1,500

Steppin' in at Mardi Gras, 2012. Cold cast bronze,
23.5 x 35, framed. Open edition: $3,500

The Red Tent, 2012. Cold cast bronze and red acrylic,
37.25 x 11.75, framed. Open edition: $975

ACKNOWLEDGMENTS

Once a year, five women get together for a week for what we call our board meeting. My daughter Isadora Gabrielle Leidenfrost and I, and three friends—Amy Biddle, Rita Emmer, and Tamara Medley—stretch one another way past where we would go on our own. This book is just one of the outcomes of our commitment to each other's growth. Thank you my dear friends.

I would like to thank Paul Cash from Larson Publications, my publisher, Anne Kilgore from Paperwork, who designed this beautiful book, and Andrew Gillis from Cascadilla Photography, whose photos render my sculptures so vividly. Thank you all for being such a blessing to me. This is a much finer book for your creative participation in it.

I would like to thank the deep aspects of Woman who arise within me as I work, inspiring me to create these stories in cold cast bronze as a way of engaging them, and the many women through the years who have helped me find words for them as well.

When I was in my forties, I teamed up with "power" and my work got a lot better very fast. It was hard to let go of me being the doer, but the results of this surrender produced a joy in my life beyond anything else I have known. Now, I serve out of love and want to share with others just for the joy of it.

narrative
sculpture by

Teresa
Moorehouse

ARTIST'S STATEMENT

*M*agical combinations of myth and matter germinate in my narrative sculpture reliefs. Inspiration arrives in the form of multicultural books and lectures on tape, which play through much of the process. When I am out of self, sculpture flows through me and I am altered in a way that allows ideas to take the form of image. For me, these images form a language of symbols that are intuitive and spiritual. When this occurs I feel the images in my body and must sculpt.

The process begins with an original in clay followed by a rubber mold. Then I make a limited-edition cold-cast bronze in resin with bronze power. Patinas of copper, silver, and gold leaf highlight and enrich the sculptures. I perform all processes in the artistic creation. The work ranges in size from three inches to thirty-six feet, and always maintains an intricate level of detail.

My work seeks to develop nonverbal conversation, using layered image-language that refers to the mystery behind the visible. For me, it is the interior language of the soul.

While I am a native of upstate New York with a studio in Ithaca, my gypsy nature keeps me "On the road again." Whether I'm doing gallery shows, outdoor fine arts shows, or commissions in the studio, home is wherever I am.

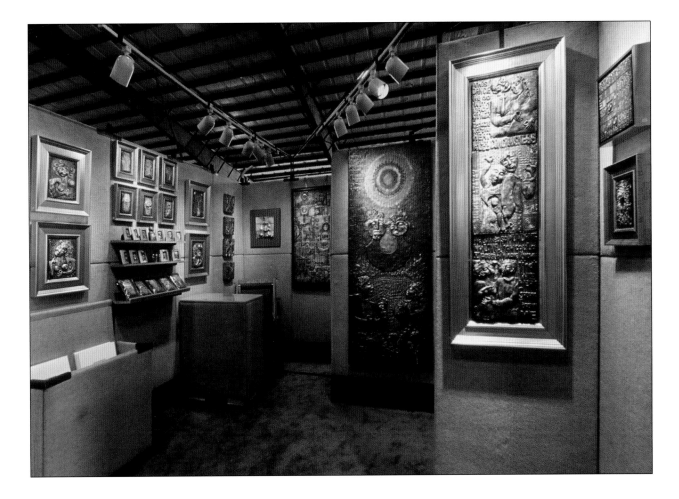

This is a typical display I use in fine art festivals in major cities throughout the United States. In this way I can present my work to hundreds of thousands of people across our country. Thousands have stopped to hear the stories.

When my daughter was a young teenager she occasionally was with me at shows. Once after listening to many women speak with me, she asked, "Mother, why do women cry in your booth?" It's because when you work from your heart it touches others' souls. She does the same thing in her work today. Being a living example is the best way to pass on wisdom.

Here is an example of a story that illustrates how I like to work.

THE HEALER

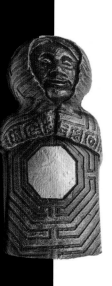

She is called the Healer and is a mixture of wisdom, wit, and woo woo—of sympathetic disposition, a love for her work, and a committed servant in both the spiritual and the physical world. She has a remarkable knowledge of plants and their properties and knows their harvest times.

And here is the rest of the story: I saw this woman in my mind and decided to make her as one of my unlimited editions. I wanted her to go into a small frame—she did not have that intention. So she is a little freestanding piece.

About six months later I was doing a show in Asheville, North Carolina. A woman walked into my booth and I recognized her immediately. I said, "You're a healer." And she said, "Yes, I'm a Reiki master and work with cancer patients." I gave her the little piece and she said, "This looks like me." I said, "Yes, I know, you visited me in my mind."

That's how I like to work, on the receiving end of intuition or whatever you want to call it.

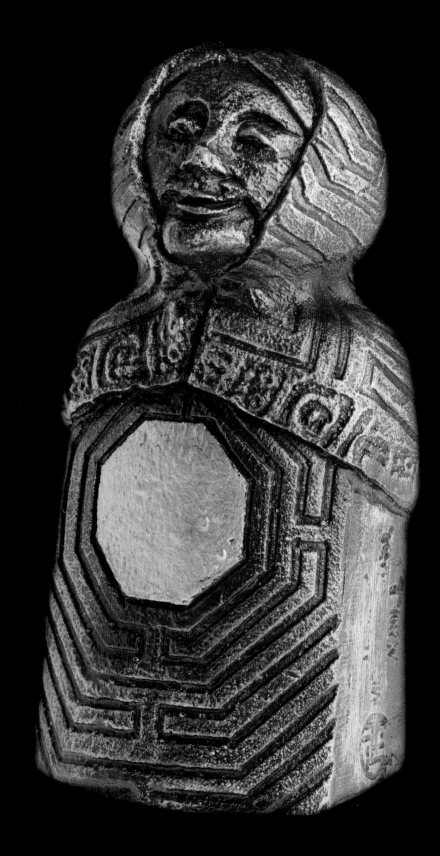

IN THE SPIRIT OF THE APPLE TREE

*t*his apple tree, abundant with fruit, awaits us.
The Garden of Eden is wherever we are, and
until we eat of the fruit of knowledge we have
no choices whatsoever.

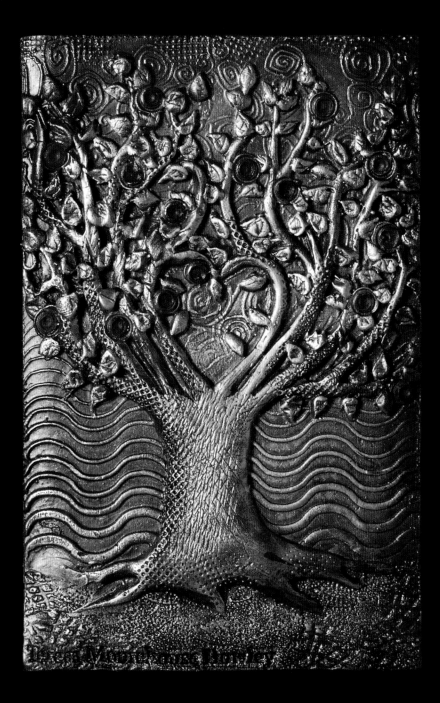

THE PHOENIX CYCLE

*t*he part of our life that no longer serves us must burn up so that new life may rise from the ashes.

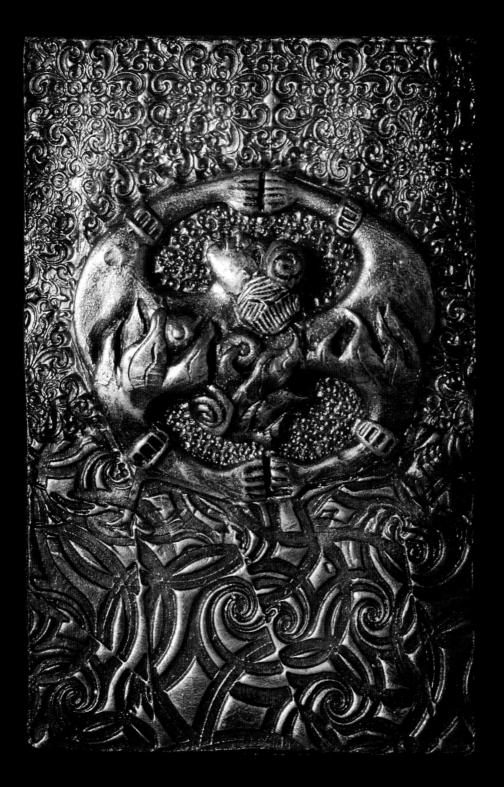

THE ANGEL

So close to us that we can barely turn around without making contact with one.

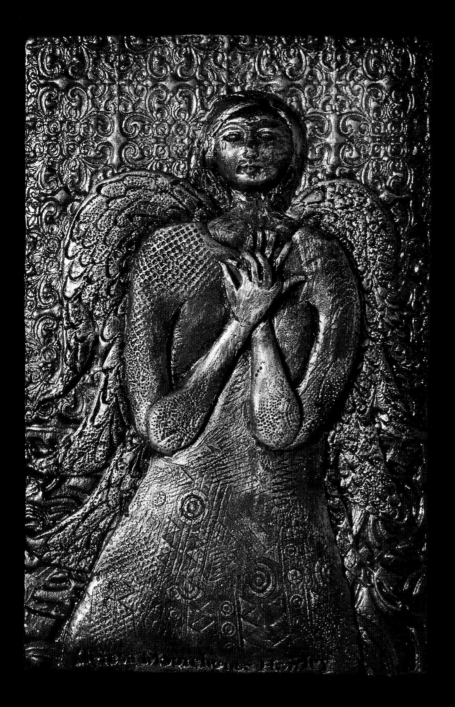

EMERGENCE

*a*n awakening of the soul. She shares her wisdom with those who wish to receive it. Sometimes wisdom counsels timing.

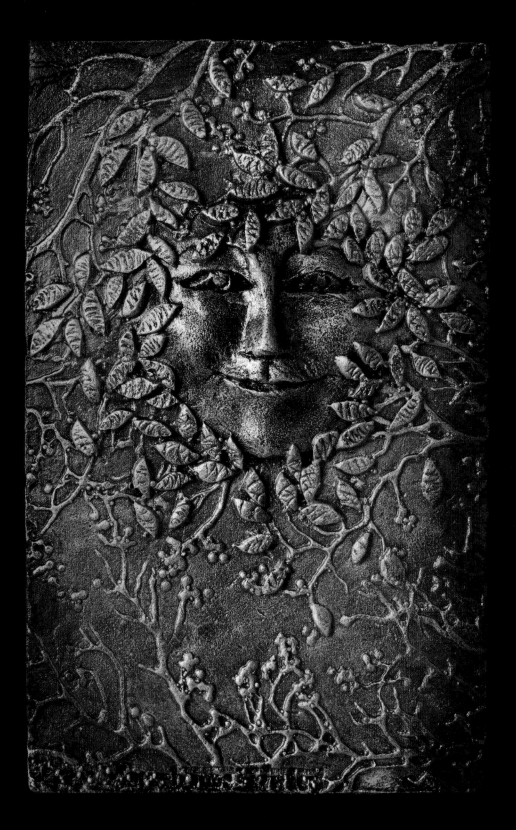

A WOMAN WITH HER COMPANIONS

a woman walks with her companions—the child, the victim, the saboteur, the prostitute, and her own animal nature.

Which will command her attention now?

When will immature fear attack?

Who is it that this always happens to?

How will she undermine herself?

For what will she sell herself?

Where will need, passion, or lust lay beyond the reach of reason?

These are some of the associates of a woman's life. It is not just their negative aspects that move us.

Our childhood dream of being something can guide a whole life.

Dislike of being a victim can produce courage and action.

Being sure of what we want and don't can guard against sabotage.

We may sell ourselves to jobs so something else important to us can happen.

To be in harmony with our natural forces makes us eat, sleep, procreate, and yes, even breathe.

This is a big thing, this glorious life we live, and we come in designed for it.

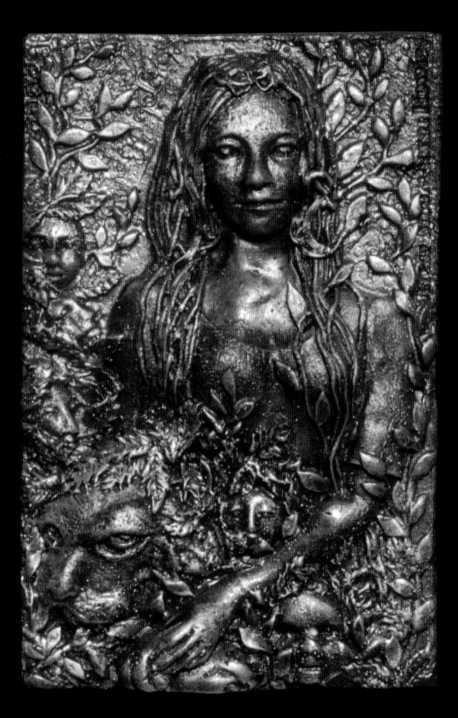

FOLIAGE SPIRIT

*t*he wild essence of the feminine in nature's environs asks us to keep some of our hairy roots and not get too tame. We need conscious women, not tame ones.

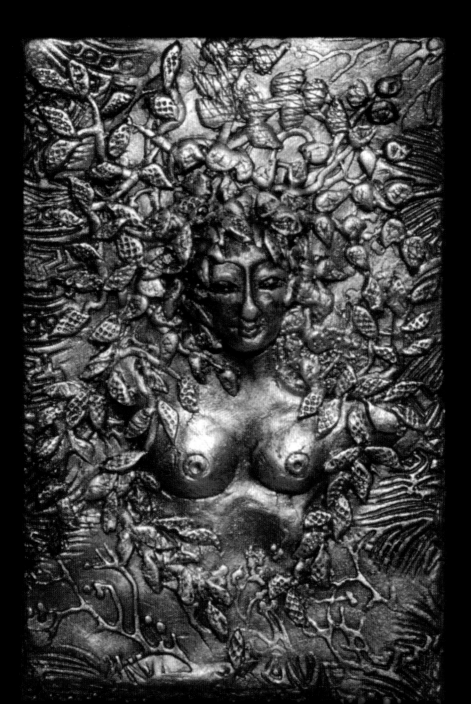

QUIET WATER

*a*s I inhale its energy, a quiet meditation captures me. The calm breeze and the hypnotic rhythm of the water will gently carry me inside.

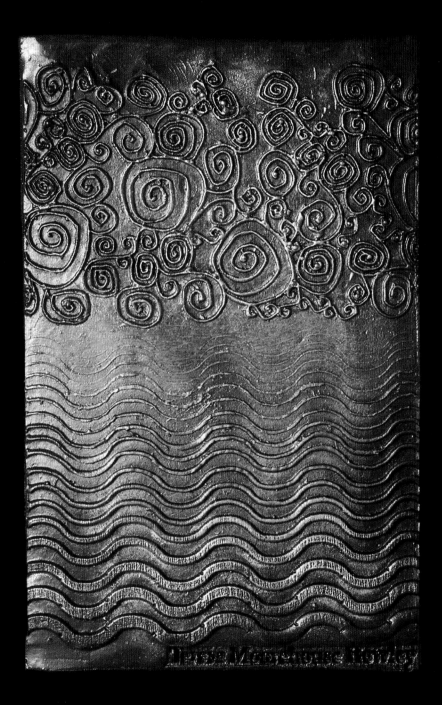

THE WORLD TREE

*W*e would be the hand out of which the tree of life grows. The symbol represents our hopes and dreams for this future we have chosen. We stand ready at the gates of this new experience. As soon as we say, "I do," we enter them.

Right on the other side of the gates are lions, and they must be fed—now. No one ever tells us this part of the story. If we feed the lions meaning, we get to walk consciously into our lives.

We are after the water of life way up in the background, which is the very best that we can make out of our experience. If we ignore the lions, they will devour us. If we feed them something that has no substance, we turn to stone and are unable to feel at all.

The first room in any experience is ornamented with stone statues representing those that came before us.

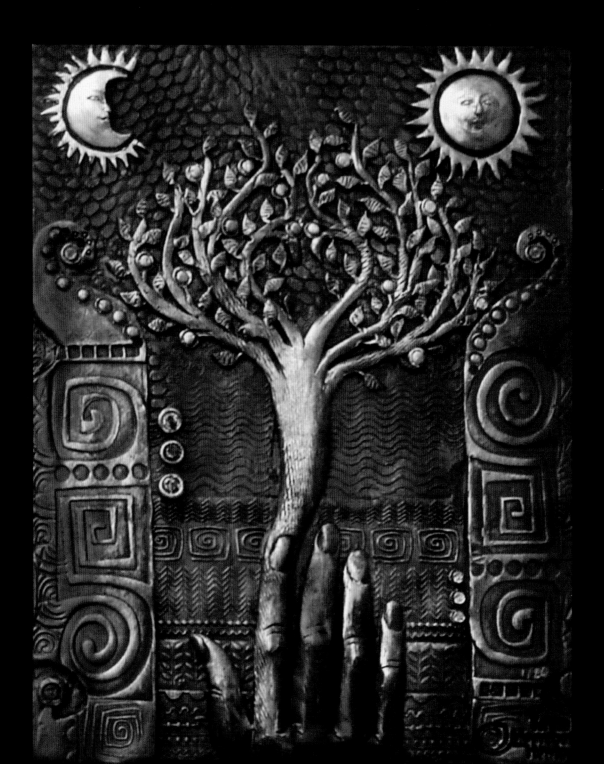

INITIATION

I come this time with the tools of vigorous growth, empowered with a spirit remembered as I manifest into matter. Sometimes we forget that we came here with everything we need to thrive.

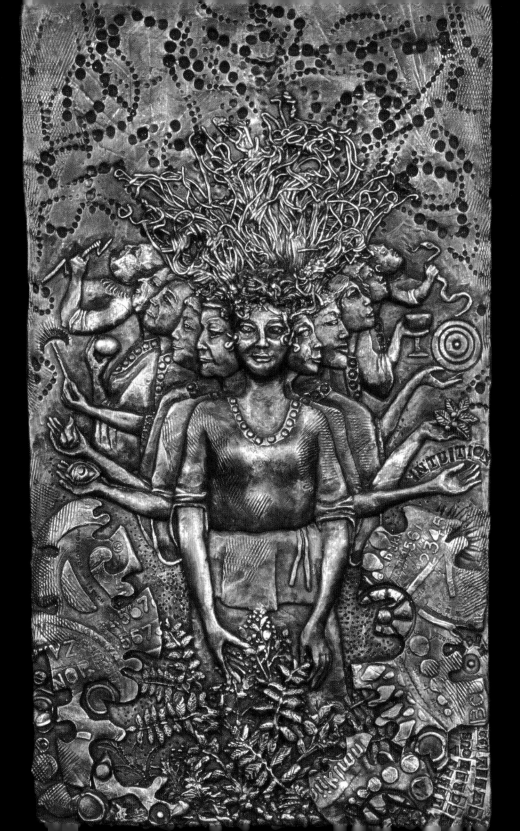

THE MYSTIC

*t*he mystic comes
with a foot planted
in each of the worlds,
the spiritual and the mundane.

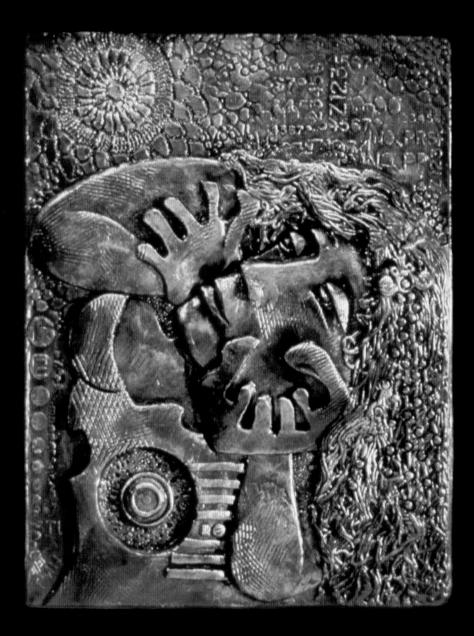

OPEN DOORS

*a*n invitation to life and its remarkable journey. Part of us aches for the interior life: If we hesitate too long, the path gets harder to find.

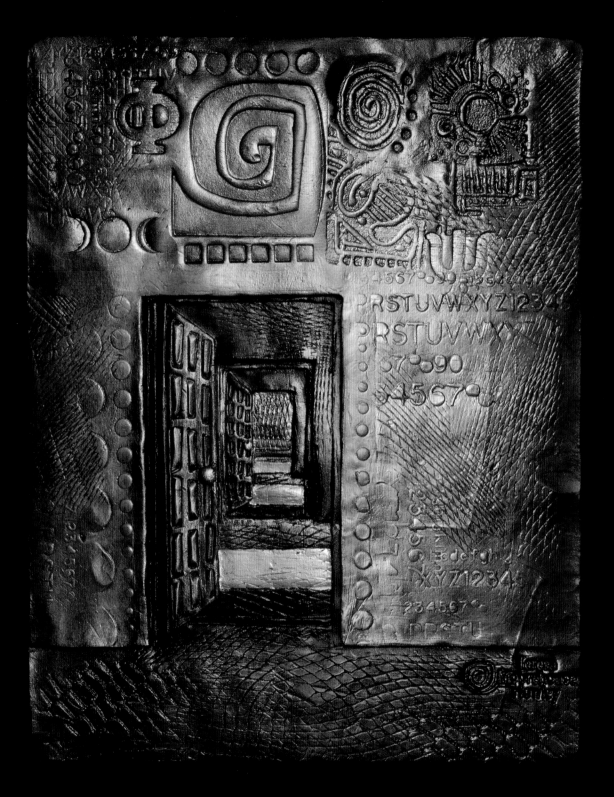

SECRET KEEPER IN THE GARDEN OF PERSONAS

I wear the masks of artist, mother, worker, daughter, president of this, and secretary to that. The greatest secrets I keep even from myself . . . Who am I? Why am I here? Is this a friendly place?

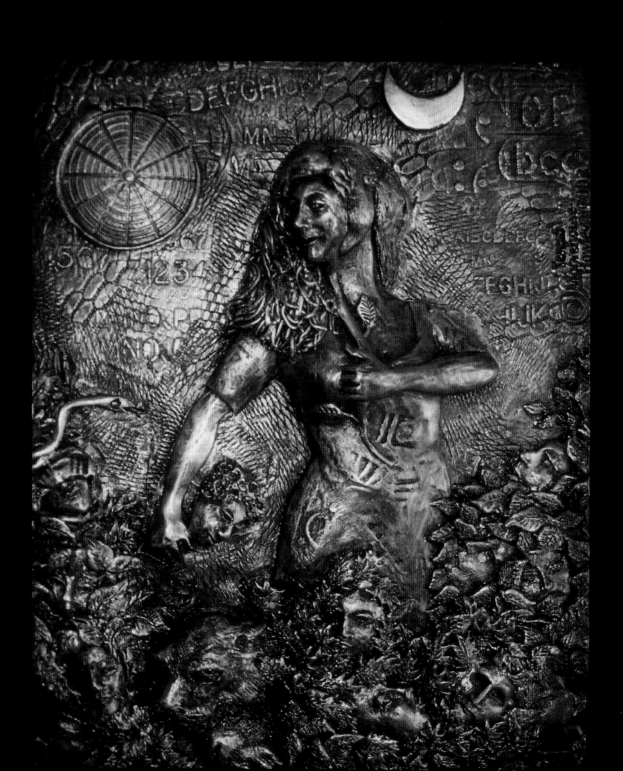

THE KISS

*i*n relating to one another we are not meant
to become one, but to individuate and
each stand as witness to Other.

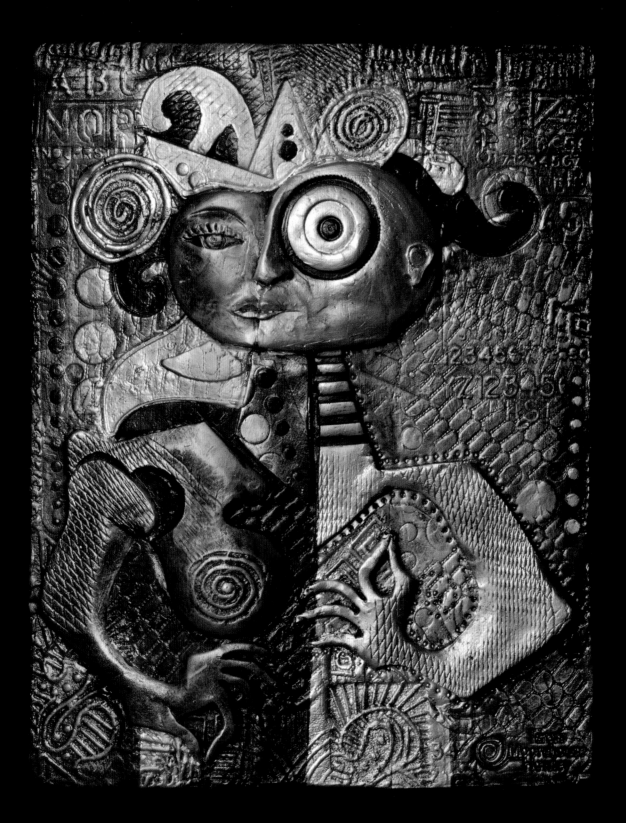

THIS DANCE
WE DO

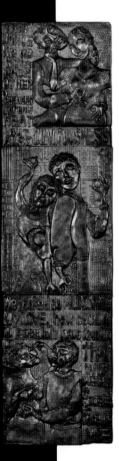

*t*his dance we do with each other produces not only heat, but also consciousness. I looked for you but when I found you it was mostly work mixed with a little part of ecstasy. How was I to know that mine is the spiritual path that awakens in what we make together?

I heard once that woman is the Goddess in the eyes of her mate. That scared me at first. But now I am awake to my task and put new heart and hope into it.

We looked so mundane my love. How could I possibly have known that we are sacred?

Forgive me.

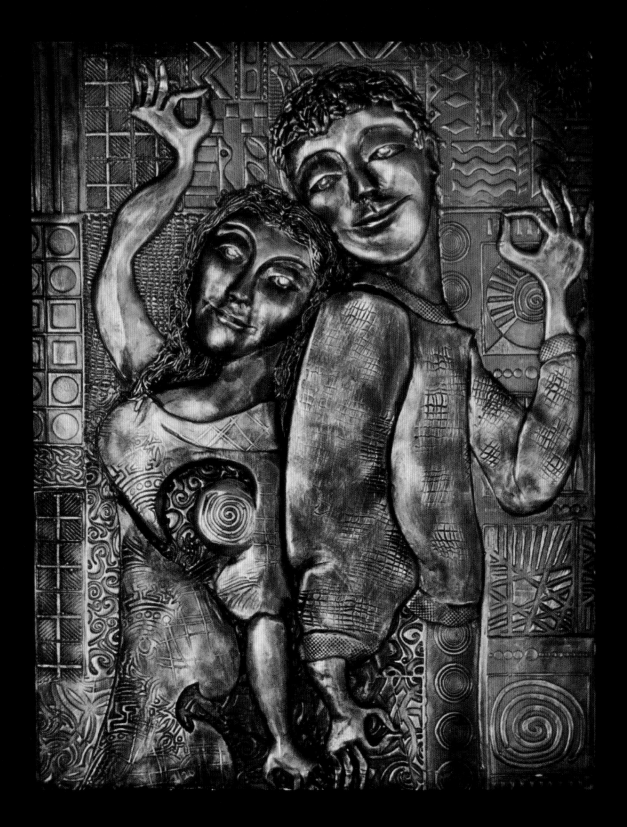

A WOMAN'S CONTEMPLATION

*r*eflection and quiet contemplation offer a clear vision for any course corrections that I care to make. Sleeping on it overnight works miracles.

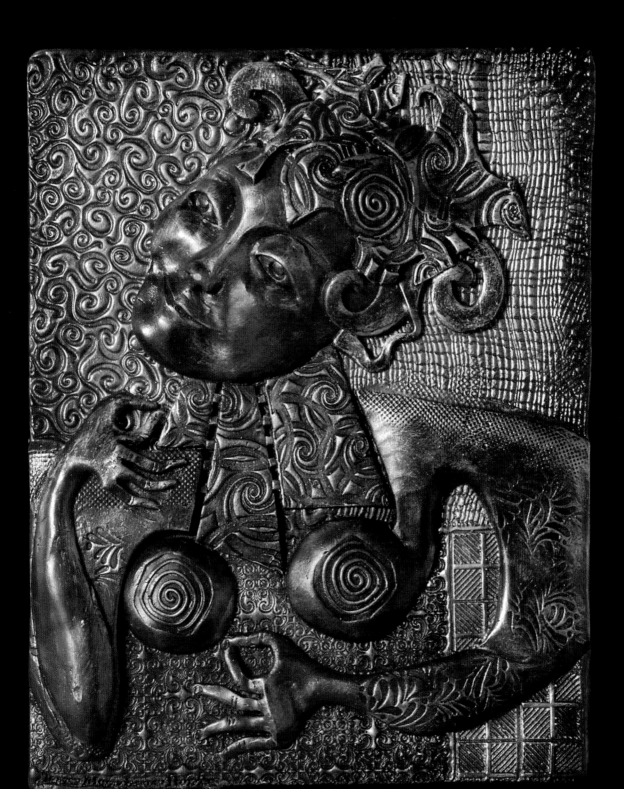

GREETING THE WORLD HEAD ON

*O*n the days that I do my hair, put on makeup, high heels, and the rest of the stuff . . . and greet the world shoulders back, tummy in . . . I feel pretty powerful. On those days, I feel sorry for the person who decides it's my turn to catch some of their chaos.

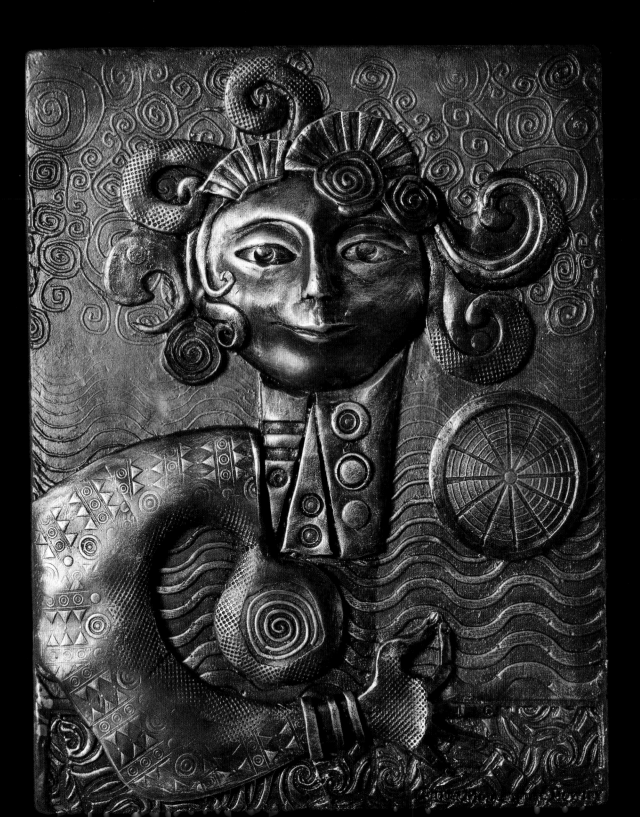

ELEMENTS OF THE LABYRINTH

*a*ll elements are active in the constant changing of our living Earth.

From the eruption of underwater volcanoes we see fire in water. The eruption creates magma and the magma creates land mass. So the alteration of our Earth home continues.

Shifting continents, mountains rising and receding seem to our eye imperceptible. Yet science tells us there is nothing seen or unseen that is not alive and in constant movement.

All this upward passage channels us into the Labyrinth. But as we move through these circuits we too are changed and reenter elemental home altered by our experience.

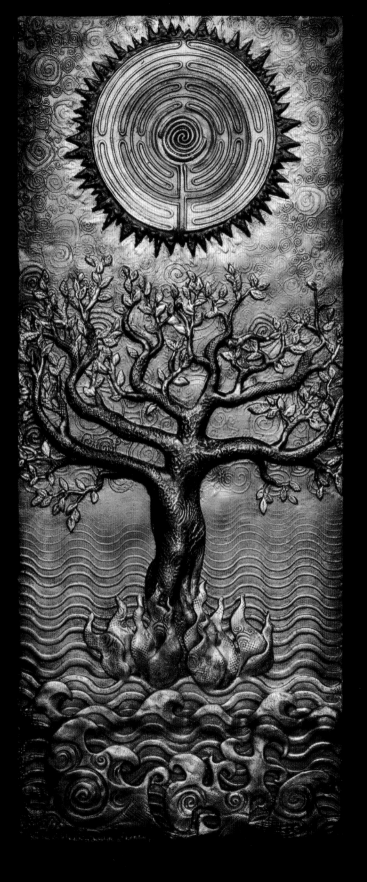

THE GOLDEN FRUIT

*f*rom out of the abstracted matter of the things we don't understand, or the things we can't quite put our finger on, this strong healthy vine of life weaves through layered time. All types of people move through our lives. Some we know, some we don't; some we never even see, but they affect our time here too. Occasionally a pattern presents itself as ground we can stand on, and for a while we comprehend; but then that too passes and gets woven into the movement of life.

When the I is born, the test is to remain conscious enough to question: "How is it possible for us to cope when we are looking for what is best for ourselves?" A common objective must be found, so that we can live here together and nurture each of our dreams.

The Tree of Life stands rooted in our own past and the grand past that came before us. It offers us gifts. It asks us to dream and reach for what we think cannot be ours. We will have to stretch ourselves, and learn to live with patience and persistence as companions. They are our guides to the rewards of a life lived in the brilliance of the golden fruit.

What is the Golden Fruit? It's what you want deep inside, what you're willing to put you on the line for. It's the thing you find to difficult to say. It's the thing you can't believe is possible. It's what Life offers when you say yes.

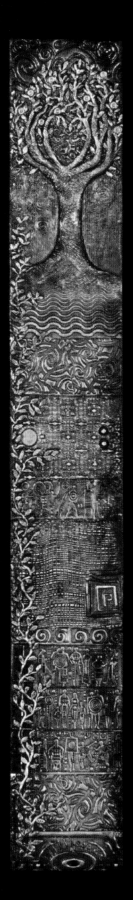

THE FALLOW TIME

*t*he Tree of Life stands rooted in our past and the past that came before us with its vine weaving throughout layered time. Its nature is carried in seasons, a designated time for everything to come into being.

But what about when it feels inside like nothing's happening, a deadness reigns. The old ones tell us that when you think nothing is happening, something is happening.

Our future is in its seedling state. Those two companions of expectation and hope are having a contest, a negotiation, but nothing has been shared with us. We can only speculate but now are too empty for conjecture.

Grant me patience to endure this waiting with no ideas to feast upon.

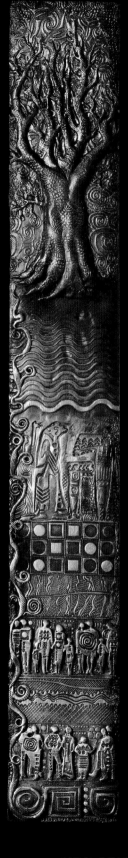
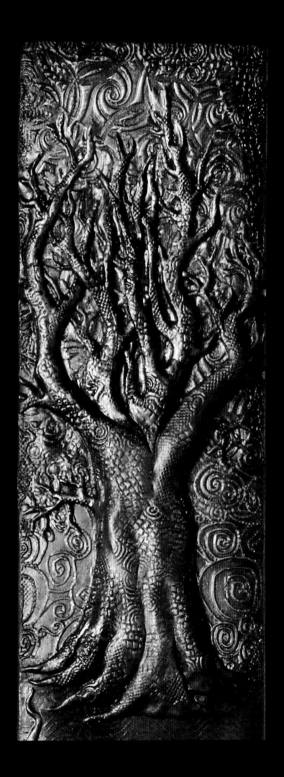

THE SPIRIT TREE

a contented, warm, loving spirit shines out and welcomes us into this tree teeming with life. All its being—under the earth, in the air, and in its branches—invites us into this realm of home.

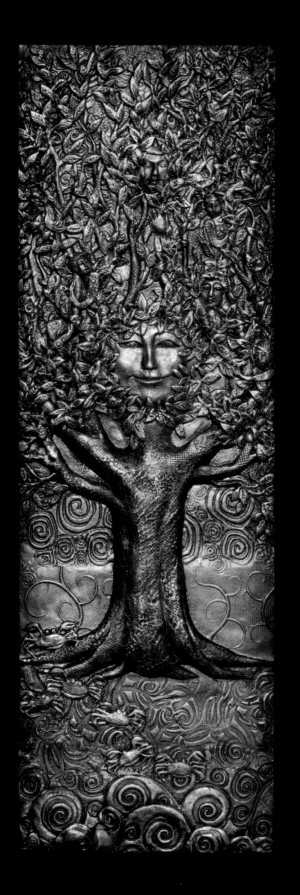

THE ALCHEMICAL MARRIAGE

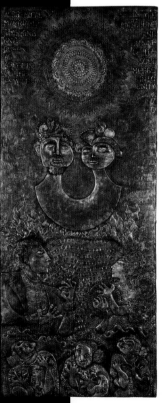

*M*any cultures have a version of a tale in which "Three Fates" are invited to a wedding.

They sanction the union with their blessings and place it in its time on the wheel of life. They also are the beings who present the idea that through the eyes, the soul of the other is known. This knowing of the other is the substance of the relationship and the ground where forgiveness is born. This is the level of marriage that many of us seek and participate in, but there are other levels of marriage

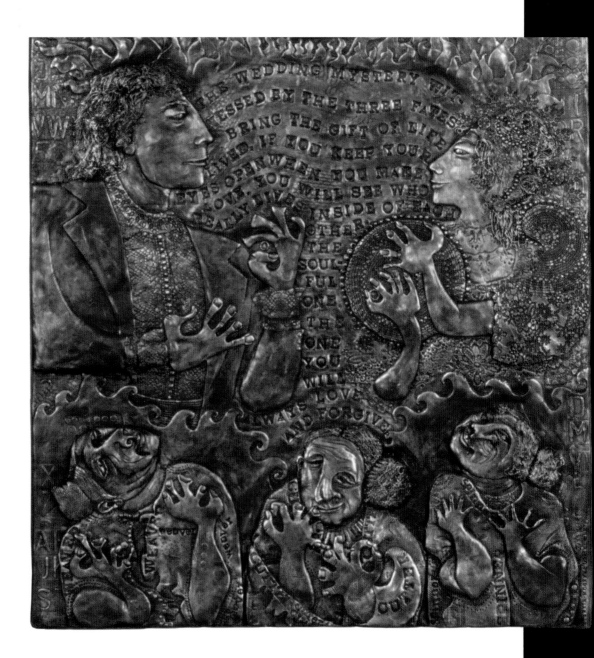

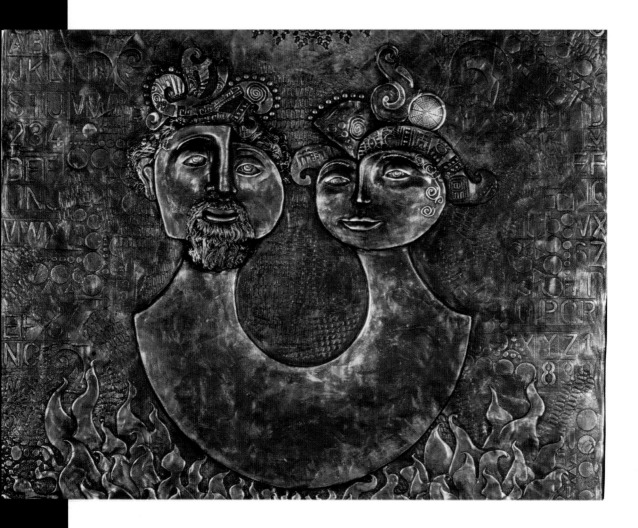

*t*he Alchemical marriage is the marriage of the masculine
and feminine within one's own being. When this happens
we don't look outside ourselves for the other. We are the other.
When we enter into relationship after this has happened, we
come as a whole being.

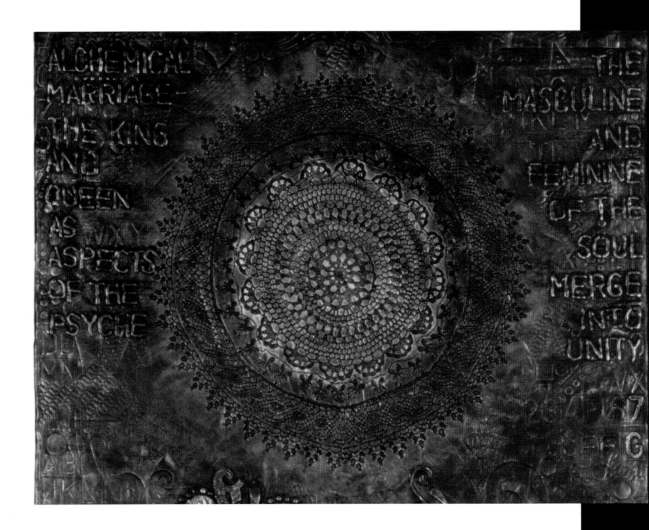

*t*he third level of marriage that I am discussing here is the
marriage to the divine. I rarely hear this discussed except by
monks or nuns or ministers. But a layperson also can be
married to the divine. I am married to the divine and that means
to me that I love and am drawn to God or something bigger
than self; it doesn't matter to me what that something is called.
The work that pours out of me as a result of being out of self is
infinitely better than what I produce without that power.
My life would be lackluster without it.

IMAGES OF KNOWLEDGE

*t*here are four sides and five levels to this sculpture.
The four sides represent the Archaic, Magical,
Mythological, and Rational. The five levels represent
Nature, Body, Feeling, Knowing, and Will.

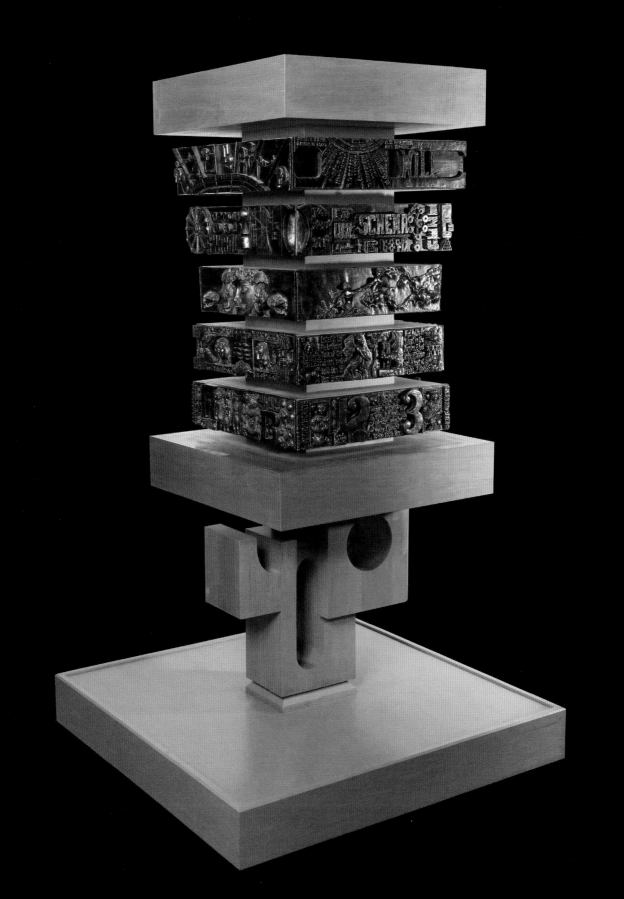

ARCHAIC SIDE

*U*nmanifest, or in image, bubbling and gurgling matter. Archaic Body—Unicellular form and embryology.

Archaic Feeling—Nature, the need for self-expression, speech, dance, music, writing, and communication.

Archaic Knowing—Five senses.

Archaic Will—Forces of nature.

A person has no control over any of the levels on the archaic side; nature is instinct to us.

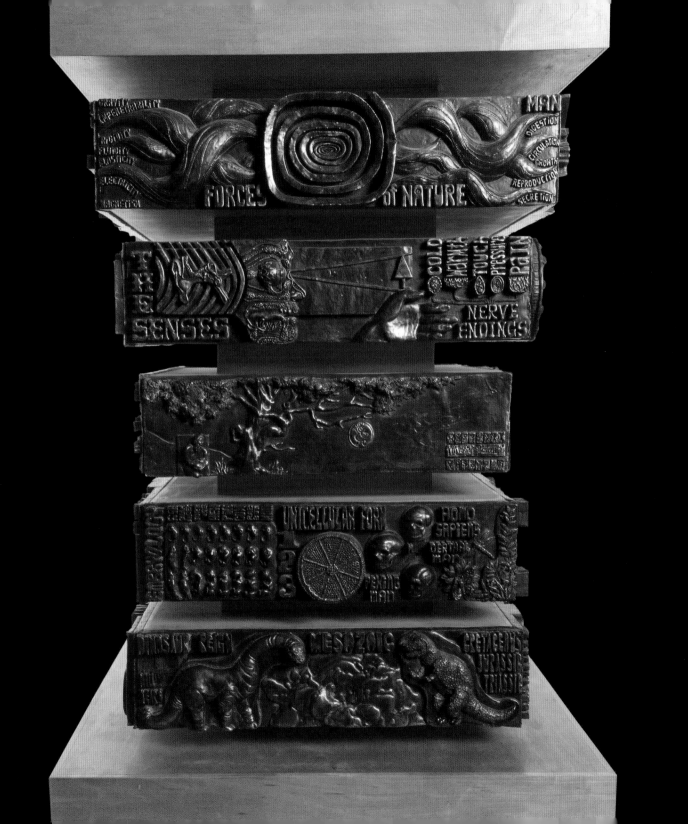

MAGICAL SIDE

*t*ry to imagine your childhood, or watch a young child play with a stuffed animal or doll. They will speak to it, feed it; they believe it has life. This is the kind of magic I'm portraying: a participation in life that is not quite concrete, a personification and animation of nature. In adults, we would see this in how they participate in the collective unconsciousness of their culture.

The second panel from the bottom is an example of the Magical body. This is a local Indian myth of the formation of the body of the Earth riding on the back of the turtle. You can find this story in the mythology of the Iroquois Indian Confederacy tribes. You also can find it in North, Central, and South American Indian tribes—and in many other cultures.

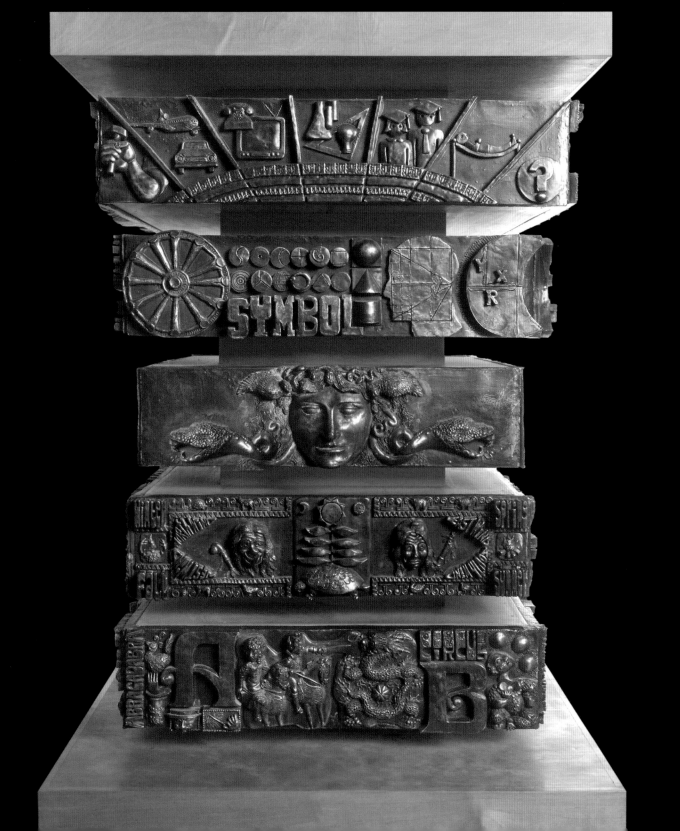

MYTHOLOGICAL SIDE

*O*n the mythological level one forms concepts about who they are, what they are, and what the meaning of their life is all about. The second panel from the bottom is an example of this. This panel depicts the mythological body. On this level we are forced to deal with our elemental nature, our desires, our fears, our hopes and wishes.

Note: All the images or symbols used in this sculpture are currently in use by twenty-first century Western peoples.

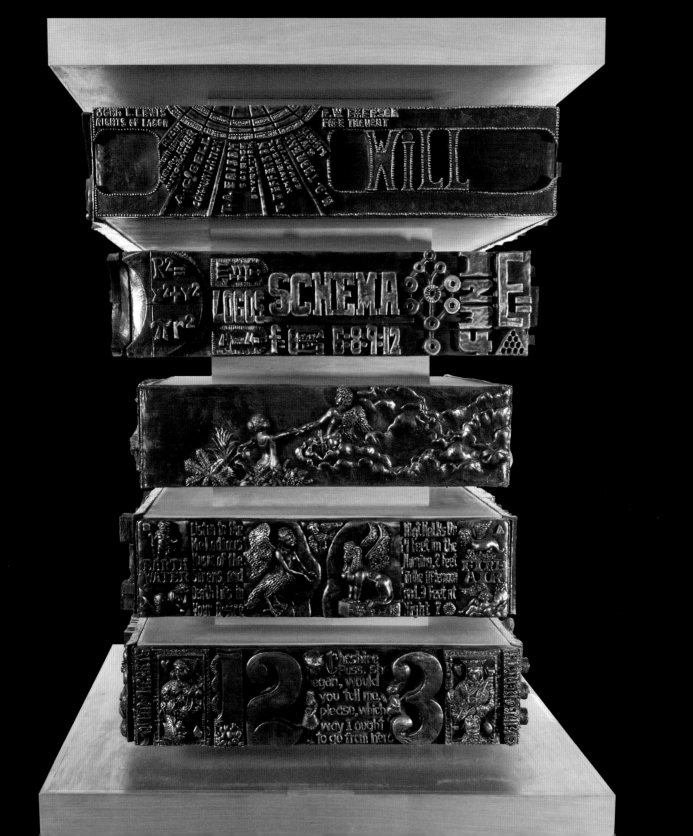

RATIONAL SIDE

*l*ook at the second level from the bottom. This depicts the Rational Body. You are looking at a study of Leonardo da Vinci's drawing of human proportion theory—Man as macrocosm and microcosm compared with the body of the universe. Man encompasses and reflects the greater whole, the universe.

Look at the second horizontal level all the way around: The Archaic Body is the development of our body through the unicellular form; the Magical Body is the development of the body of the Earth; the Mythological Body is the understanding of our elemental nature, our desires and fears; and last, the Rational Body is the integration of the body of Man and the universe.

We now have a picture of the concept of body and its importance to each individual.

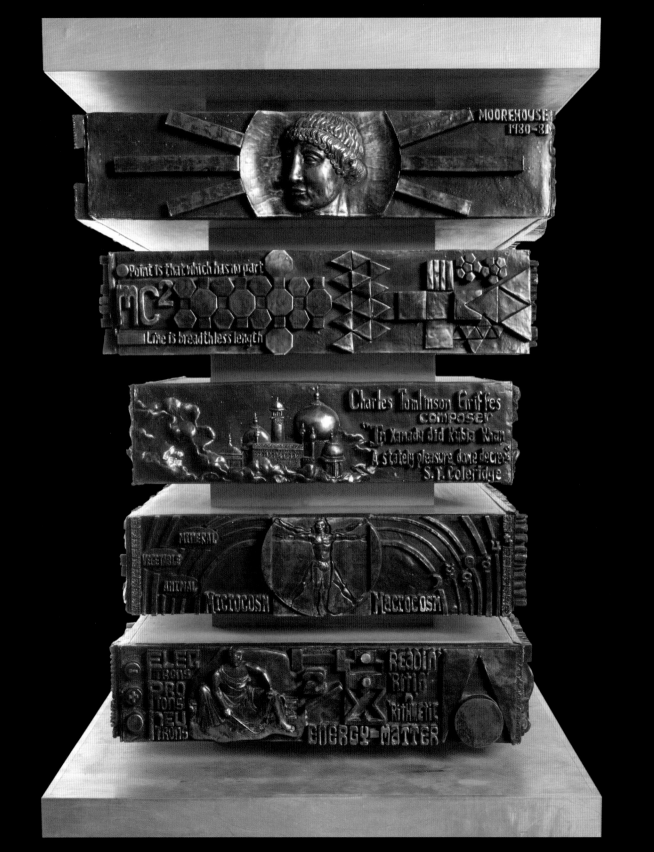

THE DANCE OF THE BODY IMAGE

*O*nce upon a time, a long time ago, just yesterday . . .
with the fetters of our western culture's idea of beauty
and driven by an addiction, we danced the lonely,
heartfelt line of hardly recognizing what is and
dreaming of what we are supposed to be.

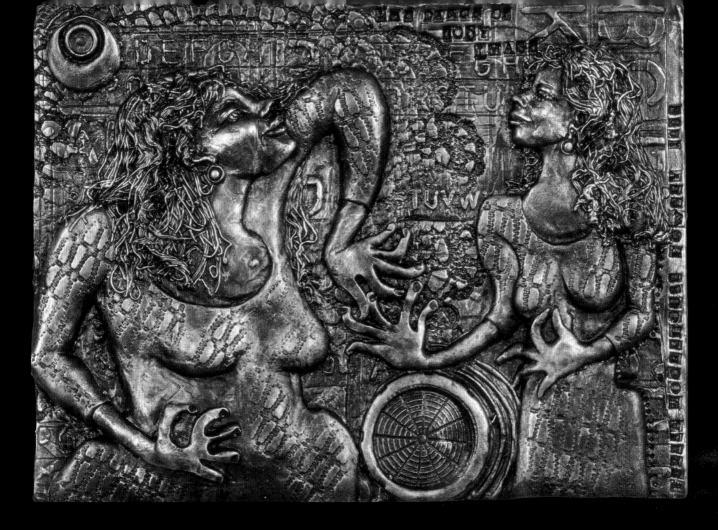

THE DIVINE FEMININE IN HER LIGHT AND DARK ASPECTS

*W*hen I found myself being drawn to the Dark Feminine—that which is unseen, unknown, unpredictable, unfathomable—somehow I wanted that experience. Like Persephone. There is the possibility that she loved Hades, and spent time in both worlds willingly. That kind of knowledge called to me.

We so often wish to show only that golden part of ourselves to others, but the dark part is where all the creativity and power is. It is the part that we are so often afraid of and others may be afraid of as well.

Without it my world had no depth.

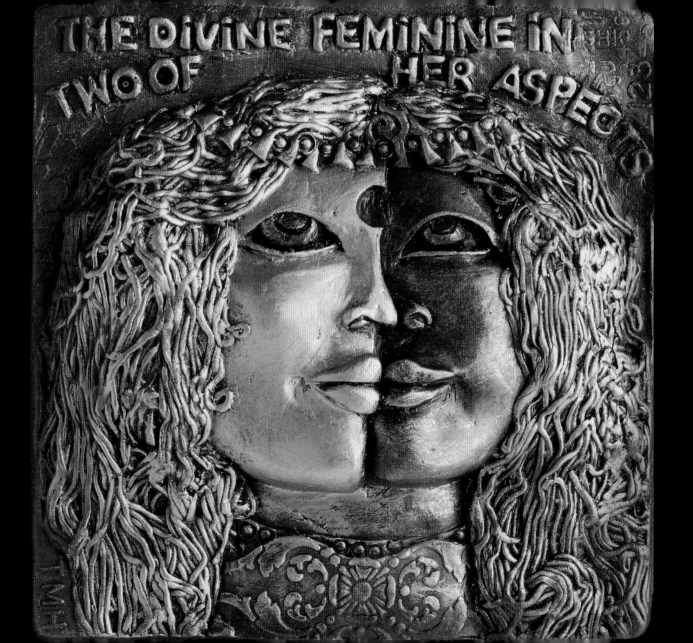

THE DIVINE FEMININE IN TWO OF HER ASPECTS

SOUND CALLING

*t*his music brings me to a place I've never been before. How can I resist so pure a sound that calls me into meaningful relationship with Other?

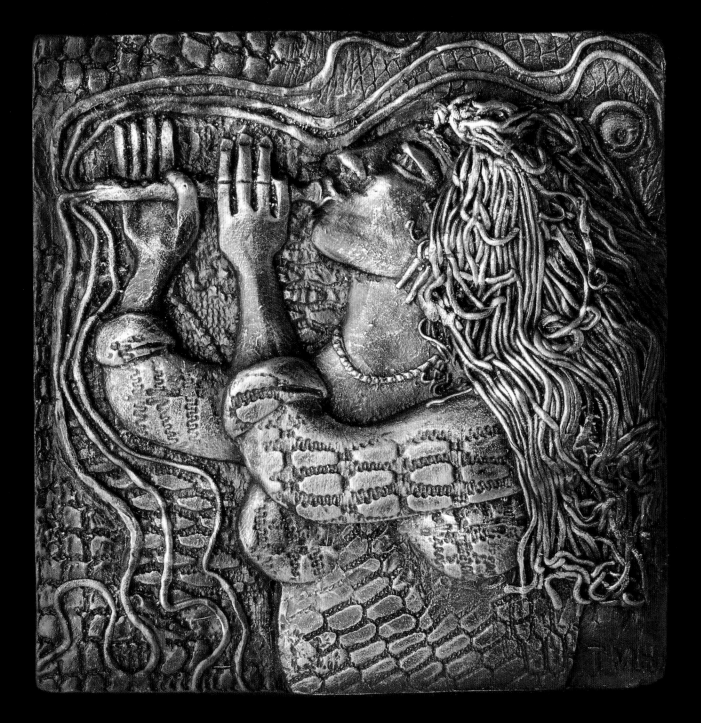

THE MILLION YEAR OLD WOMAN

*t*his piece welcomes the return of the goddess. Just as a
part of my mother is in me and her mother and hers—
all the way back to the million-year-old woman—
so too is the knowledge they carry.

To access that wisdom we can call her as simply as
this: "I want to speak to the million-year-old woman."
It's that easy.

"What do you want?" is how she answers me.

So, what is it that you want?

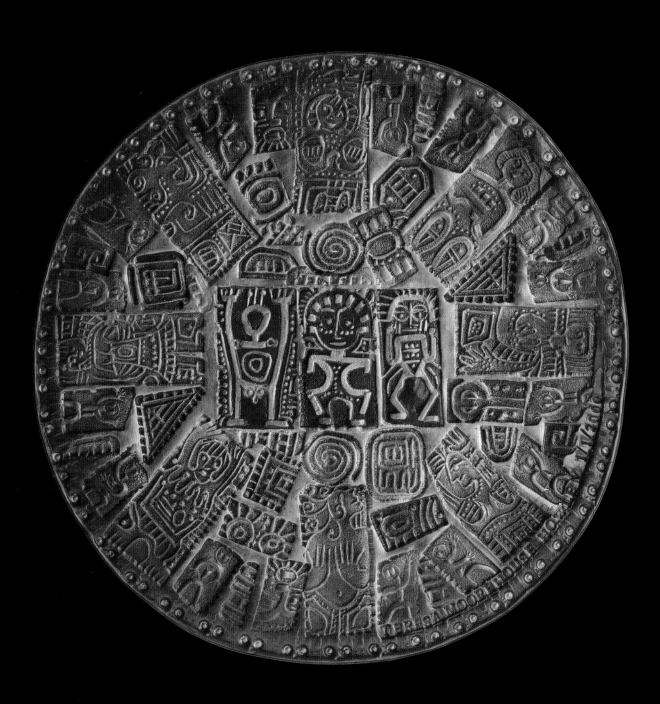

SLEEPING BEAUTIES AWAKENED

*O*nce upon a time, a long time ago, just yesterday, a young woman fell asleep and did not awaken until she was around thirty-five. This could as well be said of more than half the women in our country. We find ourselves, in some aspect, participating in this myth in one form or another. Then we wake up and wonder what happened. Sophia has birthed a new woman.

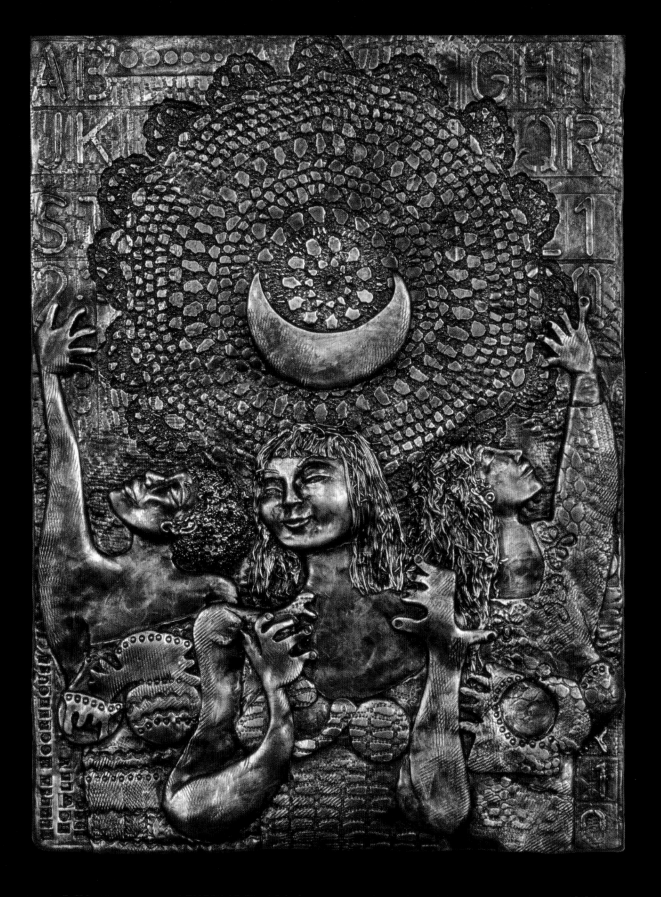

BUTTERFLY WOMAN

a crone, an old woman, a big woman with her hair long and loose, dances upon the Earth as the pollinating force. Her blessing is upon all of us, without exception.

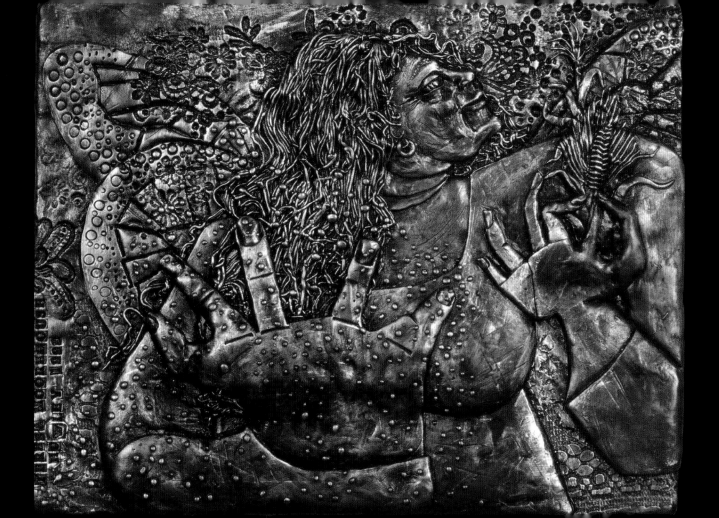

CHANGING OUR PERCEPTION

I have taken my ideas of what is and rearranged them many times within the boundary of what I think—but now to taste the consciousness of pushing the frontier out into who knows what makes my heart pound, and all my six senses come to attention.
Let's go, there is only a small window of opportunity.

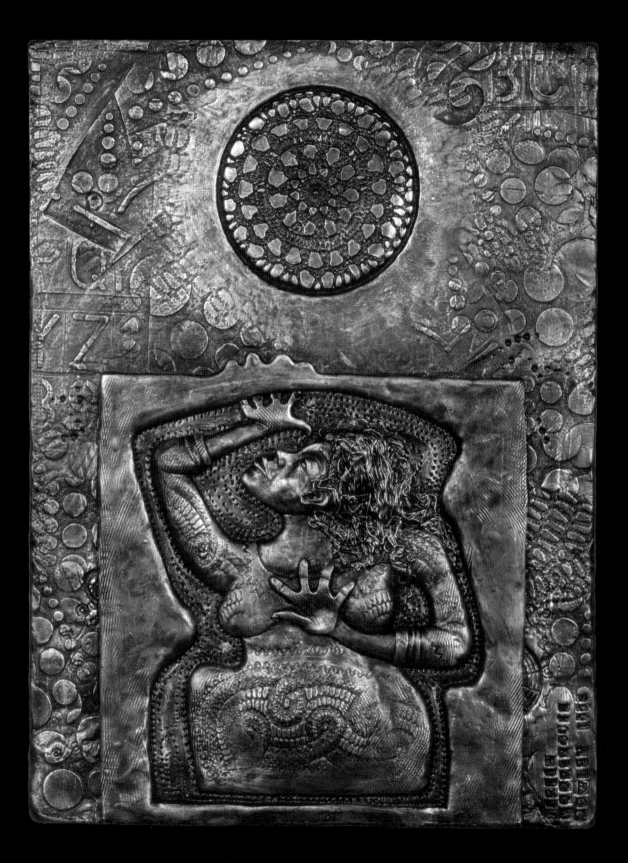

DIRECT
CONNECTION

*W*hether we are nuns, housewives, in the work force, streetwalkers, or high society women, we do not need others to do our praying for us. We have a direct connection. We came here with it. It needs no dress or ceremony. We just get quiet and go inside.

We are empowered by our willingness.

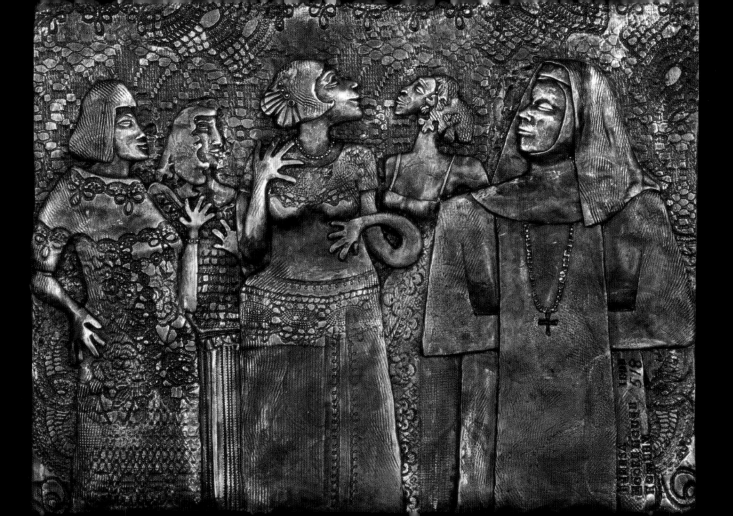

THE SKELETON WOMAN

*i*f you listen hard with attention you can hear the
skeleton woman singing the flesh back onto her bones,
reclaiming herself from a long period of feeling dry
and used up. It isn't words exactly that she sings,
it's more like a mated pitch to each bit of sinew she
manifests. A touch of spirit envelops her and the
Divine Queen builds herself anew.

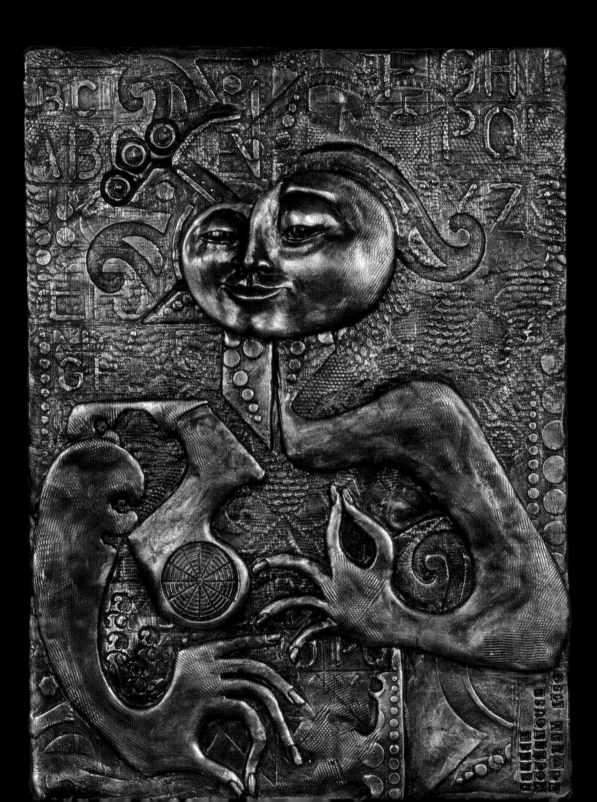

LINKED

I have had often the experience of being linked
with other women, no matter what our backgrounds
or our differences or even our ability to talk.
We are sisters and know well who each other are.

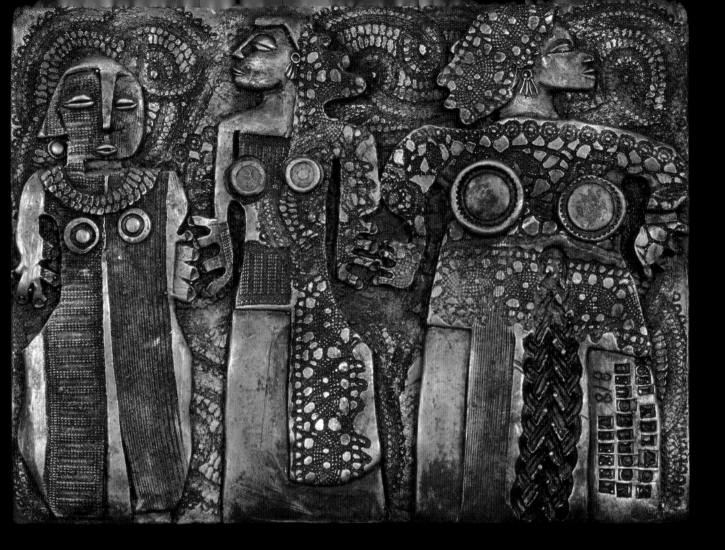

SISTERS IN WISDOM

a multicultural sisters-in-wisdom circle dance. Unbroken as time, held in the one, we receive with certainty the knowledge that the same thread runs through us all.

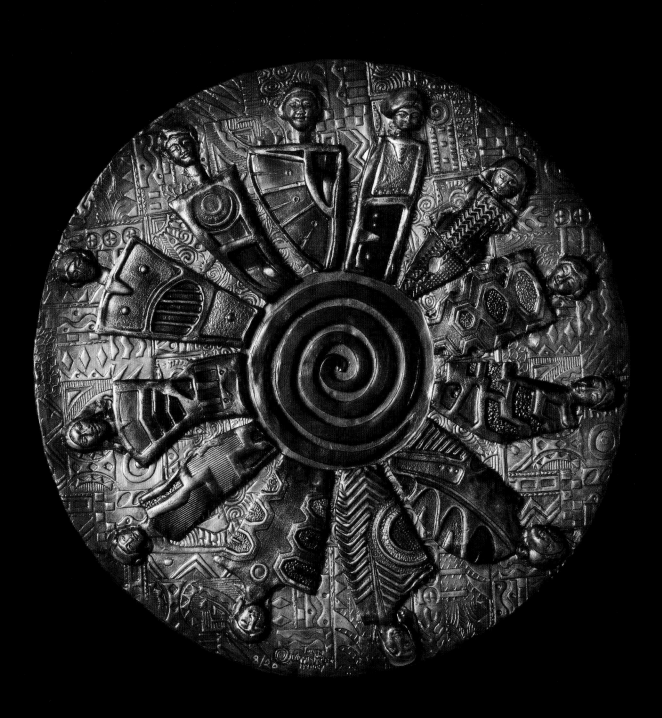

WOMEN WAITING AT THE GARDEN GATE

*W*e women know well the waiting time between what was and what will happen next. Darkness intensifies the space that distinguishes the interval between these two. This time-dragging period holds ecstatic anticipations or a fear that cannot be named.

And so we wait.

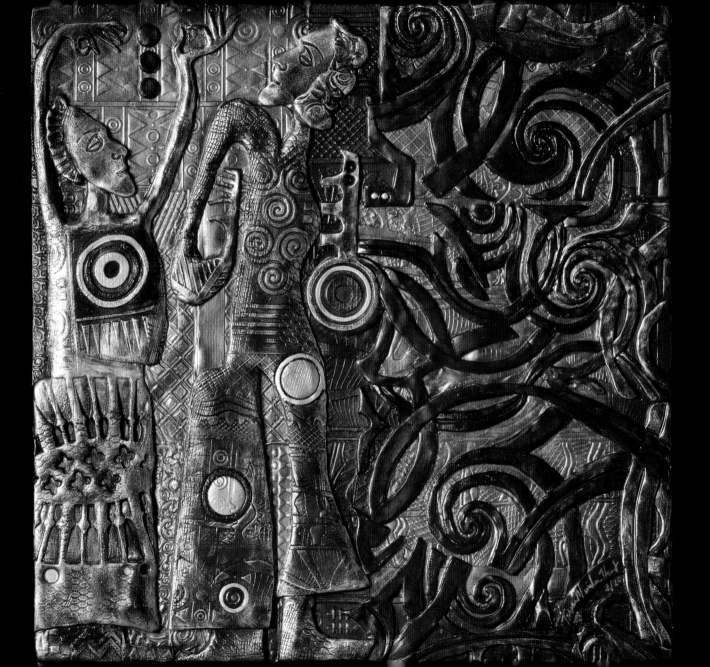

SYMBOLIC INCORPOREAL BEINGS

*O*nce, humans called on supernatural beings.

They had got themselves into situations that became problematic for them, so each according to their time and place called on angels, spirits, djinni, peri, kachinas, numen, fairies, sprites, pythons, sylvans, thunderbirds— they have been called by many names. These incorporeal beings that can become visible or audible to humans must reside in our psyche, if not in our reality, for the idea of them persists in all times and many different cultures. They seem to offer a different view, something hidden until they point it out. A guiding force or influence.

If nothing more, they are part of the symbolic mystery of an interior life in many cultures.

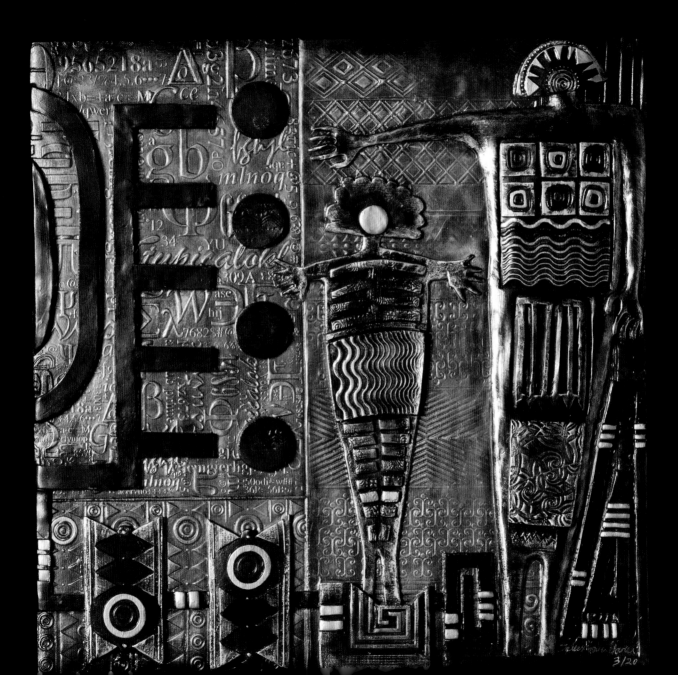

STEPPIN' IN AT MARDI GRAS

*t*here is an excitement about a marching band inviting me into celebration. The symbols clang, the drums beat, the flags airborne, the jugglers and acrobats . . . it makes me weep with joy. I love a parade.

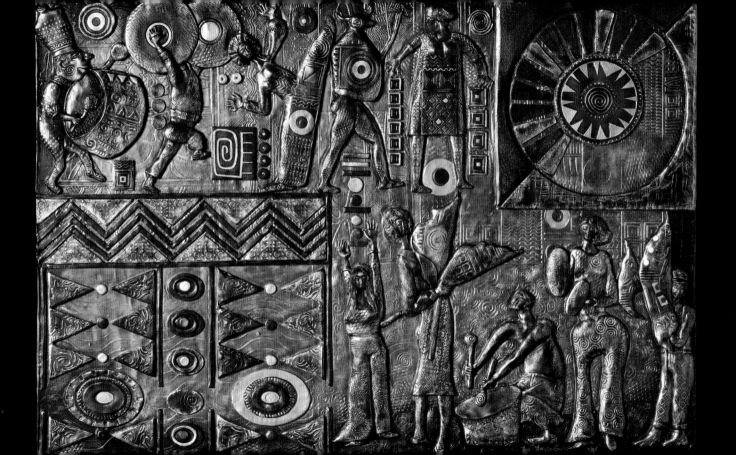

THE RED TENT

*t*he drum beats, the dance begins, slowly at first, as the women take into their hearts the sight of each other. The red textiles defining the safe space the red tent creates, and that each shall occupy, engages them with the curative feminine force . . . and wisdom gathers them around her. Then the circle dance begins.

You think I can't claim myself from the hold matter has on me? Well perhaps not, but then I have my sisters and their energy supports all women who call their power in. One by one each will summon up courage and strength from within, witnessed and empowered by the sisterhood. We now pass the drum to you.

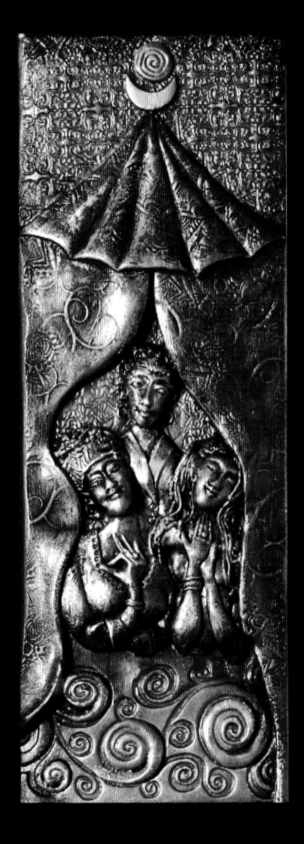

MY BLESSING

*a*s a young woman in 1964, I went to India and learned something I have carried with me since: People are people. It doesn't matter who they are, how they dress, what they eat, when they pray, where they live. We are all made from the same stuff and we need each other. Blessings to you all.